T0208175

LOST,
Lust
and *Love*

EREVU

authorHOUSE®

AuthorHouse™
1663 Liberty Drive
Bloomington, IN 47403
www.authorhouse.com
Phone: 1-800-839-8640

© 2011 Erevu. All rights reserved.

No part of this book may be reproduced, stored in a retrieval system, or
transmitted by any means without the written permission of the author.

First published by AuthorHouse 4/6/2011

ISBN: 978-1-4389-9535-9 (sc)
ISBN: 978-1-4389-9536-6 (e)

Printed in the United States of America

Any people depicted in stock imagery provided by Thinkstock are models,
and such images are being used for illustrative purposes only.
Certain stock imagery © Thinkstock.

This book is printed on acid-free paper.

Because of the dynamic nature of the Internet, any web addresses or links contained in
this book may have changed since publication and may no longer be valid. The views
expressed in this work are solely those of the author and do not necessarily reflect the
views of the publisher, and the publisher hereby disclaims any responsibility for them.

LOST

Closed Chapter

My thoughts of you were endless and pure
Eluding doubt's infections
Thoughts now tainted
My mind scatters into sporadic ways
Irrational directions
Down memory lane my heart you can find
And although I couldn't seem to spare the time to tell you,
You were always on my mind
Trust in my words when I say
Moments of you
Of us together replayed
Through my loneliest day
Days turn into weeks
Weeks into months
Months into years
Years into infinite possibilities
Yet now a soured joy moves in
It's a sweet misery
To recall the traces of you
Of me
Of us together
Realizing the end has come to this once known forever

Rising Tears

I'm desperately seeking a definite ending
To remove myself from this stagnant love affair
Watching firm rules consistently bending
Praying for a second glance
With eyes the color of a thousand tears
Reflecting much more than the eye can see
Enough confidence to fight off my fears
You promised never to love me on the chance I'd rip your world apart
We were all the same, so it seemed
Angels shattering the stained-glass windows of your heart
Countless times I've cried for you, waiting to hear your voice again
And even though I knew about the tangled mess
The difficult situation that I was in
We've stayed together through morning fights
Temptations
And all of your egocentric lies
Now you can keep the candle lit in vein throughout sleepless nights
With myriad tears residing in your eyes

Bitter Sweet

A love like this
Like hers
Selfish and without understanding or attempts to
Stifling, never growing
Spring of faith's death.

Blossoming tears
Overflow and lose their reserve
Etched in pain
An obituary of my heart.

She is
painfully indifferent
heartbreakingly beautiful
My dying heart screams for mercy,
Yet it dares not wish the suffering, the tears, and the confusion upon
 another

Written Relief False Belief

The pain I have inside
has now decided that it won't mend
So I have to realize now
that day dreams don't last
This situation has to end.
My tears won't let me see
You surely cannot know
I want to be beside you
More than anything
Nevertheless, I have to let you go
The hurt that I feel
A poison sure but slow
I try to move my life on but
the pain doesn't stop
It just continues to grow.
If only I knew
What wickedness I've done
If only I could correct the wrong moreover,
End the sad bring back our fun.
Yet I have to go on
With emptiness inside
Where once there was a loving heart
Now it is where only pain resides.
And what more can I do
It really hurts me so
To know the feeling for you is still strong
Yet I can't hold on to you
You simply want to go.
How I wish I could hate
And curse your very name

Would that bring satisfaction?
Would it somehow bring an end to my pain?
But it is all over now
I have laid my heart to rest
You cannot hurt the dead I'm told,
perhaps this is for the best.
Goodbyes they seem so hard
I really don't know what else to say
Your happiness in future times
for that, I really and truly pray.
As tears, begin to fill my eyes
I just cannot write The End
I thought somehow that writing this
would help my heart to mend.
But it just isn't so
I know it cannot be
Through all our time I thought of us
Thoughts must change
Now I must think of me

Lies

I can't say how sorry that I am for hurting you
Sorry that I lied
Killing our love's virtue
I lied because I love you
Keeping you hidden from the
Self correcting truth
Things I'm still slowly getting over
From present day
Back to my youth
Believe I wanted you in my life
I didn't plan to hurt you
Just deeply wanted us to be
Now that you know the truth
There is no longer a you and me
I want to say I'm sorry
Doing better was a definite must
I hate that I misled you
Betrayed you
When you gave me all of your trust
I didn't want your heart but you gave it without hesitation,
So freely
I feel that I gave you mine
But due to the lie
It seems difficult to believe me
We did our time but neither
Worked hard enough
And now I'm apologizing
Realizing blame is definitely something tough
But I'm calling your bluff
I don't know what else to do

I wish I could go back
Recreate the math
No longer two plus two
But two multiply to become one
Feelings surely are not done
Carrying guilty burdens
Well over a ton
I want to start all over
I'm asking for another chance,
To re approve, reaffirm
The once overlook feelings
My hard work did earned
A wind driven ribbon
Now ties us together
Severed by no man
Say you want me back
Because I want you as my woman

Mind Body Soul

Silent kisses dance along the edges of my lonely lips.

They miss the sensation of an almost forgotten kiss, a nearly forgotten
reality that once was unforgettable, indescribable.

Now they yearn quietly, living uneventfully.

Sadly whispering to my hands to trace your silhouette that's etched
into my sheets

Into loving memories, Everywhere but in my presence.

My hands ache for just one touch of your gentle skin.

To run my fingers through your hair while gazing into your eyes would
soothe all arthritic pain.

Memories of embracing you as we lay.

These feelings bring a smiling tear to my eye and a blissful pain to my
heart.

My mind thinks of you while my body mourns your murdered
affection and my soul becomes a void.

I miss you, mind body and soul.

Secrets

A secret is unloved,
Left uncared
Yet lingers around
Seemingly always there
Although it's new
It's kind is never that rare
They find joy in being kept.
A false reality that doesn't seem quite fair.
Secrets remain unknown
But always seen here and there
On a path that usually leads
Down a road to no where
They are suffocated by lies
Forced to breathe without air
Most live long eventful lives
Only to die in despair

Reflections

As I reflect on all the right and wrong
That I've done from the start of all of this.
Questions invade my thoughts.
Where did I go wrong, did I do right, what did I miss?
I wonder why I didn't walk away when
I more than knew you really didn't care
When all you gave me were headaches
During my times of joy and more than my share of burdens to bear.
I believe in my heart that I was in love, but then again, maybe it wasn't.
For when one gives his all to receive nothing in return, can't be.
It's now turned to some kind of resent.
Your touch burns my skin and your image singes my eyes
Being alone isn't the worst.
Yet being alone when you know you shouldn't
Is a reason why a grown man cries
Alas, it's all but too late to change anything.
Too late to dwell on the is, was, wasn't and the random fears.
I never wanted to be alone, but all I have left, besides heartache,
Are my heart fragments and tears.

Lonely Rain

Tonight the rain fiercely falls without regard for others.

It beats upon the Earth as I lay reminiscing in my lonely bed

Deeply wishing it was once again, our bed.

The tap dance of the raindrops reverberates through the house, echoes
through my mind.

Just as the rain my heart leaps and prances from the sight of your
image; from the vivid recollection.

This dance is partner with a down pour of pain from the reflection of
clouds on my soul's windows

Mimicking the weather, in the past I fell hard for you. Yet now just as
bad weather does, the winds have calmed, the clouds have passed
and falling has now come to an end.

Regretting The Sunrise

Within my mind, our memories haunt me.
Freedom embraced, eventful moments
that leave me crying though dreams.
As I wipe the clinching tears of joy
from the corners of my sleepy eyes,
Do you ever miss our times?
Within my mind, I hear your voice,
Echoing though miles of road
Recalling our talks about everything and nothing.
Simultaneously
Are your thoughts now shared with another?
Within my mind, I see you smiling.
Laying next to me on the bed, or the couch,
Our energies flowing in unison,
harmony known only to the rarest of soul mates.
As music of the universe drifts into the dark,
Do you miss these arms?
Nightly in my heart, I search for answers.
Answers to the numerous questions
It finds on a daily basis
Is there any way to let you know how I regret my mistakes?
A key ingredient of my life is missing
yet I wake each morning trying to ignore the taste.

Once

Honesty once had a home,

And truth once resided in this very place.

Love and living once had a meaning,

And angelic beauty once was personified on her earthly face.

Once there was freedom,

Where I ate, slept and lived like I ran a kingdom.

Once I thought that this joy lifted me to a place no one and no thing
 could ever take me from

Happiness once was alive,

And once I thought I had a better half.

Once there was a time where two people came together to become one,
 I guess I had the wrong math

Her persona seemed so great,

Within our relationship the possibilities seemed so vast,

All I ever wanted,

Was to come home to a woman who would be my forever, the one who
 would be my last.

Fate took my once and created another plan,

Or maybe she had another love.

But it all fell apart,

I laugh now at the stuff that dreams are made of.

Gone now is that once, it shattered its cage in order to fly away.

Now I walk alone in this dark, shadowed path,

With no her, no once, no light to guide my way

Battle of Mind and Heart

Pain and confusion
Results of an epic war
Raged within
Logic seems infinite
Knowing no end
Heart, bruised and beaten
Can't muster the strength
No will to begin
Emotional expression
Heart's battle cries
Fail to unrequited feelings
A man cries
Only logic replies
With devastating remarks
Next time heed the wise
Give no aid
To choices the heart has made
Feelings fade
Embrace being afraid
Chances on love,
For sense of security
Its time for a trade

Distant Memories

Her eyes,
Her touch,
Her smile,
Are all things that seem to refuse to escape his every waking moment,
His every sleeping thought.
As he stares out of the window
His frigid apartment suddenly warms and fills with joy.
His once dead smile now reincarnated to shine again.
His mind, now lost in a dream world,
Revisits moments of holding her
Times of kissing her lips
The hope of what it would be like to wake up to her smile once again
God blesses his body with a sigh.
A gentle breeze blows to knock over her photo.
Snapping him out of his trance
Bringing him back to a cold apartment
Back to a loveless world without her.

Broken Destiny

I had to come to terms with it
The horrendous pain I put you through
Hard to believe it came from a man
The man who repeatedly says he loves you
Inside each of my tears,
A gallon of pain
A pint of regret
With indefinable fears
That you will never forgive me
I was never a man for an apology
But if it need be
I no longer have a problem saying
I'm sorry
I pray because it's killing me
The guilty thoughts filling me
The sorrow of what I've done to you
This travesty
Ending this thing once happily known as
Our destiny

Morning Mist

In bed watching the sunrise
Glisten off of the freshly dropped dew
Dreading the soon to be outcome
Another lonely morning without you
A lot of my dreams realized
Now I can only stare at the emptying cages
As a way they flew
So many words I didn't say
Because I lived in assumption
Believed I didn't have to say
What I felt you already knew
The emptiness, overwhelming
We lost what we both surely had found
I now stare at frozen images of you
Body sinfully round
Wondering if moments of us enter your mind
While desperately wishing to have you around
We gave up on trust
It created more than doubt
We let each other down
A man of many hats
Yet I can only manage to wear a fool king's crown
As I lay here dying of heart break
I feel the need to say this
Its so long, so detailed
This extravagant list of reminisce
The way you laughed
How you smelled
Each and every kiss
I know it was love

Shame I only realize it now
Now that you're missed
Epiphany hits hard
My heart commits suicide
Bleeding life from both wrists
In dying breath my heart
Whispers your name
As my eyes begin to mist

Lust

Sexual Intention

I finally have you in this position
From what your ailing I'll make better with
passion inspired incisions
I will have you screaming for God
Like you're practicing that Ol Time religion
I see you and I moaning under the covers,
Share this prediction
Come join this vision
Don't worry about the outside interference
You're under professional care and supervision
Built like a brick house
Can I come inside your building?
Can I keep you in my possession?
How these words encourage your thoughts
You would think psychology was my trade
My profession
Rest your feet, I'll give you a ride
We're going in the same direction
You have never known this kind of lust
Nor my type of affection
Tell me the kinky things you have already done.
Now let's do them again
Relive your sexual confession
You won't know what's coming next
So stop all the guessing
Simply enjoy the excitement
I've come to erase confusion and doubt
To bring much needed enlightenment
I want to send shocks through your body
Electrifying you

With bolts of African lightning
Make you jump a bit more because this sensation seems
A little bit too frightening
Only in a very good sense
Question,
Can I have you now?
Have you finally been convinced?
Inside of you I plan to travel
Touching each and every inch
No you're not dreaming
But in case
Let me give you a pinch
To see if you will wake up
Let's go at it like those who break up
and then make up
Your whole world I'm about to shake up
You in my arms
I will take up
Giving you what you've been wishing
I'll put things into action if I have your permission
Doing anything and everything to satisfy you,
Yes I'll accept this mission
These thoughts floating in my mind
I felt I had to mention
The thoughts for you reaffirmed
Because you have me standing at attention
So excuse me and forgive me for my sexual intention

Passionate Exploration

With attentive hands and flavored oil
We bless each other
Bodies shiver then soar
To heaven with an utter
Of exclaimed silence
Your body welcomes
The sexual violence
A need to please, hence
This night long session
I've touched, teased and tasted
Each and every section
Following your hands
As the point in the right direction
The squeeze of your lips
Leaves a man exhausted
Sexually whipped
From the repeated ecstasy trips
Deep breaths caused by
Gyration of feminine hips
We make room on the bed
By pushing aside the clothes
Sweaty and tired
We lay and reminisce on those
Past events of recent
The air still holds
Our passionate scent
Of will power relinquished
A smile precedes good sleep
Knowing all yearning has been extinguished

Silhouette Fantasies

Silhouette fantasies
Often pass me by.
Yet my consciousness is shackled by the images of your smooth hips
and firm thighs.
I long to caress
Your voluptuous curves,
But I dare not take haste.
I'm feeling a bit romantic so
Your lust carriage waits,
To take you to euphoria
While passing heavenly bliss.
Your gentle lips seem to linger without the presence of my passionate kiss.
I'm enticed to pursue you
Like a predator stalking in the dark.
I know you feel it too,
The precise caressing seems to have set off a sensual spark.
Flood gates open leaving
Nothing else to wonder
As the heat warms the night
Our bodies go asunder.
Enjoyment reaches endless possibilities now that fears have died
Our hearts can speak in whispers, to allow our flesh to collide.

The Ocean

The temperature rises,
as the tide becomes high
A pale moon shines above,
and splashes light across the sky
An awkward noise is heard,
one like a sea gull's call
Drift wood crashes against the shore
Knocks down the ocean reef's wall
Love and lust synthesizes,
to become a beautiful and infinite potion
As two bodies sink and swim in satin and silk ocean

Midnight Passion

The clock ticks away as the hand passes midnight.

Lusting thoughts invade my dreams making all yearning seem right

It seems so long since we've become sexually drunk from the cup of
passion.

Always uncontrollable sips giving no regard to rations

I awake to the scent of your body oil,

Which has been gently caressed into your skin.

Almost as if you were aroused by the same

You rise from your sleep with a grin.

Looking to play lustful games

Our bodies speak to each other

Yearning to return to the sensual field

Throwing away all caution and hesitation.

Ignoring any yield.

We swim in our ocean of pillows and sheets.

You moan, as the taste of ecstasy graces your pallet

So sweet

Staring into your capturing eyes, I gently taste you

Sampling your flower

Savoring your nectar

As it continues to overflows

Draining all of doubt's power

My tongue traces a path from your toes to your neck

Temperature rises

Bodies tense in anticipation of what is next

You grasp my shoulders as womanhood consumes manhood

Lock and key

We fit perfectly

Opening doors from this world to endless others of

Sexual unity

Mental Orgasm

Every time I see you,
A sensation overwhelms me
If allowed then I would
Stimulate your thoughts
Before I intoxicate your body
Doing things to you no one else could
Showing you the difference between
The everyday, each and every way with me
Penetrating the abyss of your lustful thoughts
Invading your deepest memory
Take a hold of yourself
Close your eyes
The feeling is there
Disregard its birth
Don't over analyze
Open your mind and visualize
Infinite possibilities
The kind that are never too much
New depths of pleasure
So many ways to have you
Feeling me before we touch

Sensual Games

Ask no questions
Just do the same as I say
Take your position
Get ready
Let us play
Remove all foreseen doubts and move closer to me
Close your eyes and open your mind.
This will enable you to clearly see.
Let's play a few games
Naked twister is a good start
Right hand on hips
Tongue on the lips,
Where your legs meet to part
Limbs intertwined
Abstract art
Caressing your hips,
Your ears, and your eyes
I know you like it,
From the tremble in your thighs
I'm tasting your tender breasts and sensitive neck
Now slowly maneuver,
Even I don't know where I will go next
Let the fragrance of your body refresh my soul
It keeps me yearning for more, wanting you in whole
I played a fair game, and moved with gentle traces
Join the voyage
Exceed new heights, let's go to new places

Come Lay Beside Me

Come lay beside me,
Feel how flawless our bodies come together,
Fitting, lock and key
We seem to be created for one another,
From how our lips touch ever so gently.
Mouths open pressing tighter,
Tongues dancing, flickering and waving teasingly.
Let our hands slowly explore and roam,
Our souls quiver as we touch tender spaces.
Bare bodies become intertwined,
Slowly yet vividly we become one tied together like sensual shoe laces
Our souls release their sigh,
Such an overwhelming and absolute feeling.
While our bodies move to the rhythm of our lust,
Earthly vessels rocking and reeling
Thoughts empty leaving only here and now,
We've taken this situation to new heights and can't recall how
Eruption, exploding passionate lava.
The time of this anticipated union has now arrived
Come lay beside me
Give our hearts due time to speak and thrive.

Sexual Symphony

My heart beats
to the pulse of her wings
Like a queen upon her throne
She majestically lays drifting
From Heaven and Earth
Between gently scented sheets and whispered moans
I grasp her tight
A grip my hands have never known
They dare not to let go
Craving
Needing
To taste her delicate skin
Inch by inch
Gradual movement
Slowly working my way in
Butterfly kisses down
Then back up her spine
Your body releases a sigh
It has become away that
You are finally mine
Better yet I am finally yours
This ecstasy that I once dreamed of
Is more than I hoped for
Completion is perfection
As I indulge myself
In the magnificence that is you
My tongue dips into your abyss
Sensual colors so true
Used to paint
Orgasms upon your body's canvass

In life like proportions
Bending you to my will
Leaving you twisted in various contortions
It is uncontrollable
The musicality of your moans
that's filling the room
Echoing through my ears
Your eyes fill with exhaustion
And satisfied tears
So I splice
my body from the soul
fusing it to yours
so that I may groove fully
to your beat
This erotic melody
Honey sweet
Me and you
Close
Ever so close
Intertwined
Surpassed levels to become one mind
Limb after limb
Swaying, rocking
in this created ecstasy
Dancing to this
Sound of sexual symphony

An Encounter

Tongue tracing various body art on sun kissed skin of motherland decent

Her body voluptuous and fit, causing sinful thoughts

Uncertain if it's hell or heaven sent

Crying out for God like you're back in Sunday service looking for
 salvation, repent

About this soon to be

Enjoyable yet intrusive biological experiment

Causing sensations of which You've never experienced before

Both lips scream out, yearning for more and more

As blissful pools begin to pour

Your mind take a journey to new world

Just let it soar

A new love scene steamy and long

Let's write it

The re-enact it; recite it

Tell me how it feels

Let me know how much you like it

When I lick it

Stick it

Nick name it

While stroking your kitty as it

Stalks your love birds

I'm counting trips to ecstasy

First, second,

No this has to be the third

Seemingly from the melodious screams I've repeatedly heard.

Finally I've devoured you

Leaving silent moans as your last and final words.

We Creatures

Let us dive head first into the flames, igniting
We're creatures of seductive fires.
Interlock male and female, both yearning
For the heat, the sweet explosion of overdue desire.
I splash into the fantasy, all consuming;
Going blissfully insane,
My passion for you deep and fully ripe,
Long after, sweet warm flickers will still remain.
My skin sizzles with your touches and kisses,
yet it burns and aches for you to do much more;
My soul is kindled, too. For it knows what true bliss is,
My mind, my heart I freely give;
Through you I am made whole, a man complete.
This is only foreplay for us,
We creatures of the seductive fires and heat.

Love

Hopes And Wishes

Hopes and wishes
Passions and tenderness
They were so close
Oh so dear to me.
I couldn't believe the
Blessings in my life
All those wishes
Of togetherness
Upon tomorrow
Wishes to remove distance
We are never far
From one another
Wishes of love
Of caress
Turn to actual pain
Realistic depression
To leave and you walk away
My heart won't let you
My soul can't let you
Slip through my wish

Journey To Love

Open you heart so I may lose myself in you
Give some instruction
Take my hand in yours and guide me through
Allow me to bask in the radiance of your smile
And drink from the cup of your love if for nothing else,
Just a little while
Drenched in ecstasy I collapse helplessly on your sun kissed shores
Having never known this overwhelming sensation,
My body yearns for more
I dive head first into your soul
where passion is invented
Going deeper and deeper till we reach the abyss of satisfaction
Having accomplished what lust intended
To a new height of excitement
Higher levels of sexual pleasure we have ascended
I rejoice for now your attention has finally reached my grasp
Without hesitation
With confidence I can truly say you are mine at last

Drowning To Breathe

I am drowning
Slowly losing myself
In an overwhelming
Ocean of you
smell

taste

touch

Mental hints
Subtle notions of you
Frantically trying
To find understanding
of the mystery
Once blind you've removed my hood
Allowing me once again to see
The countless moments I have spent being with you
Rapidly evolved to unbelievable dreams realized through you
Tell me this mirage by no means is a fake
My mind can't take another let down and fractured heart can't bear
 another break

My Foundation

A hypnotic stare at heavenly reflections from an angel's smile
Keeps me transfixed on love's beauty, makes all efforts to see it all
 worthwhile
She is so much more than a person I can love
Indescribable
She's my rainbow after the storm
When December blows she's June, the constant warm
In my mind she is my one and only
And for the word
I love you solely
Time without you can only be known as a waste
And I will love you
In any case
From your dainty toes to delicate face
In your hands is where my heart lays on hold
There is no blanket
That cures this welcomed cold
No net to catch my tummy dwelling butterflies
Or change the view of the world through these eyes
The soul wants to say
With you it belongs
Where it needs to stay
Always here with you
Ever near and dear to you
Till Heaven takes my borrowed breath on my last earthbound day.

Exposed Crush

I have always cared for you
But you belonged to someone
So I played the waiting game
Now that you don't
Will this change anything?
Or will things remain the same
I care for you it runs deep
The true depth only God can know
Always there when you needed to talk
Holding my feelings back
Hoping they wouldn't show
I haven't seen you seemingly for ages
It's killing me
Does it hurt you this much?
Or is it a great possibility I
Simply should not expect such
Emotional rollercoaster
Do you mean everything you have said?
I must be hearing it wrong
The imagery plays with my head
Regardless of what happens
However the cards I'm dealt play out
I thought it best you should know my heart's longest yet silent shout

Released Expressions

Deep within me, there lies a place
Where beauty is clearly defined with every glimpse into your
 enchanting eyes
It is like the radiant sun in the sky shining down onto my very soul
There to offer me an indescribable sensation
Teach me, crawl with me leading me to righteous, Everyday you're with
 me,
The closer I come
To seeing the glorious light
Teach this boy to love like a man
Show me the path, show me a better way
Be patient; trust in me, as I in you
Take my hand and lead me on how a man should love you
Love me and I will be your man
Let me love you and you will be my only woman.

I Need

I need to wake up to touch you, the drum of your heart, and warmth
from your body.
To feel the joy of your sweetness as we are in unison make rhyme,
Sweet melody
Passionate screams seemingly heard by everybody
I need to feel you holding me while you fuss about me making you
late for work, and if I'll be late myself, possibly.
I need to come home on time
to prepared dinner, sometimes my favorite ones or your specialty
I need to lay your head on my chest while we listen to late night
melodies,
Creating late night epiphany
I need to wake up three in the morning to you kissing my chest and
wanting me.
Afterwards fall asleep with passionate replays of our recent session still
haunting me.
I need to know that you desire my touch in even a brief absence
I need to praise our past
Wish for a future
While embracing your presence
As my greatest present

Submerged Emotions

If ever I have felt like this
It has never been oh so right
If ever I believed in love
My faith has been restored this very night
I'm quickly falling
And I must say honestly, I really don't care
I can't wait to hit the bottom
Because I know that you're smiling face will be there
Your every kiss and every smile sends chills that run farther than
 ocean deep
You always know what I'm contemplating, answering my heart's silent
 plea
Reach out and take my hand in yours because tonight our spirits are
 going to run
Leaving behind this dreadful, uncaring world of hurt
Our two spirits will come together to be one
I turn around and look
Expecting you to be right by my side
Instead I find you where I now desire to be
On the other side of this great lover's divide
Still, I feel that we're connected
Seeing the same stars in tonight's summer sky
I wished those moments would never end
Yet most importantly, I wish I'd never have to say goodbye

Heaven's Masterpiece

You are the finest thing
God has ever created
All of manhood stares in amazement
At this beautiful,
This radiant ninth world wonder that is you
Your prolific curves and
Lustful outlines
The power you possess over mortal men
I just as the rest fall helplessly into your captivating smile.
So immense is
your beauty that it overwhelms my conscious thoughts and dreams
Transfixed my eyes become
On your heavenly perfection
One can't help but to stare
From head to toe a fundamental work of art
A living symphony
God's Masterpiece

Passion Fruit

Sometimes it's not the fruit that is forbidden
Yet the eyes are bigger than the stomach, lust bitten
Countless excuses given
As to why the fruit is wrong
Rather than
Admit the fault
Bias judgment by default
Bruised fruit too often is picked then seasoned to heal with salt
Torture needs to halt
Let the awareness start
One can eat of this fruit if truly hungry at heart
Don't just see fruit
Sweet, salty or tart
Yet see peace through chaos
Abstract art
A masterpiece in the beholder's eye
Beauty after the rain, blue sky
Witness and cherish it or
Just pass by
A cornucopia of possibilities
Endless supply
So take a gamble with the fruit
Step to the table and roll the die

Fit Together

Man and woman
He and she
Or just maybe
You and me
Fit together
Hand in glove
Lock to key
Possibly
A mirage
Somehow
A false reality
For strange thoughts
Now provoke me
Nurturer to nurse
When I'm sickly
Wife to bear
Kids to love and
Bounce on knees
Examining any and all
Of these
Infinite possibilities
Endless joy throughout eternities
Uncover the lies
To reach epiphany
Make progress by
More than just small degrees
And finally rid myself
Of this soul killing disease

Educate Me

Educate Me
Enrich me with you
Share what you dream
The places you wish to explore
The things that keep you calm and collected
Those that ignite your fire
Leaving you yearning for more
Teach me you
Both the inner and outer
Whatever makes you smile
All of the pain you've been through
Only from education
Can I cure the betrayal infection
This heart breaking flu
I'm striving to achieve a higher level with you
To understand
To comprehend,
Capturing the evasive target of love
Receiving joy that knows no end,
To know everything you need and want.
Soon to be solved mysteries around each and every bend,
Together can we plan for tomorrow
Yet live for only today?
I've learned that you are the best place for my time and heart to lay.

Admirer

We cross paths
The day, the time
Its clockwork
Always the same
Has me daydreaming
She's a stallion
A free spirit
That won't be easily tamed
Especially not by the shrewd whistles or redundant catch-phrases
The cookie cutter game
The mundane lines we men spew
I know, I know
I'll admit it
I've been guilty of doing it too
There's something about her
My mind is not quite sure
I just need time to think it through
Can I gather the confidence
Be forceful yet gentle
Loose yet tense
Possibilities replay
As I'm checking my pockets for mints
What do I say
Races through my mind the closer I move
Maybe something simple
Something easy
I need romantic
No I definitely need smooth
Could I get by with just being truthful
Inspiration from Heaven

Right now could be extremely useful
But since I'm on my own
Hello lady, I think you're beautiful

Celestial Goddess

How does one sum up the beauty of such a thing I call her?

A smile that's like that of an super nova in the midnight hours

Eyes that sparkle like a star falling from grace to land on the surface of
man's heart

I wish upon this star in hopes to reach her in a manner no one ever has
or ever could

To bless her heavenly body with a touch that fills all voids of her
universe.

North star guiding me toward new destinations along this harsh path
of life and love

My every waking moment

Orbits around vivid day dreams of her and I, of us together.

I just pray that one day Heaven will present the opportunity to be the
moon to her sun

So we can make a spectacle as we eclipse

Breathing

Inhaling,
I breathe your
Exotic fragrance
Sigh, passionate essence
That resides in the air
During your unwanted absence
Basking in your radiant warmth
That thing that few men
Take the time to notice about women
Your lovely perfume that holds fast to my body and linen
Exhale

Inhaling,
I take all you in deeply
Going beyond superficial to show all the love and feeling you
 reciprocate to me
Yet it is not just for the love
Of any
It's the love of the confident heart, the purest there can be
Exhale

As I inhale
The nectar of your womanhood
then exhale
Us in a deeper meaning
I absorb and give off
An enlightening joy that sends my heart rapidly beating
For without you here to inhale, then exhale
I would suffocate,
My soul would have no reason to continue breathing

All I Need

All I need
Is a chance with you
To prove to you
That you're my everything
Hold me, care for me
I want to be with you
More than anything
My heart is bursting with emotion
The love I have for you
Runs fathomless deep
A heart's ocean
I need to be with you
If but for a brief moment
Words can truly do you no justice
Nor the hours of dreams
I have spent
Rearranging and changing
The fears of failed love attempts
Lacking the expression and follow through
Seemingly there no better time, no better way to say
I love you

A Taste

I want a taste of you,
the sweet you, the sour you
the you that swings in and out of moods and various attitudes.
I want a taste of you
the funny you, the silly you
the you that tickles my heart to fix in place a radiant smile on my face.
I want a taste of you
the strong you, the understanding you
the you that helps forge me into a new man never known, a better man
 than I could be on my own.
I want a taste of you
the freaky you, the sexy you
the you that sends lustful ideas through my mind set brought out by
 the curve of your desirable silhouette.
I want a taste of you,
because of who you are and what could be
So there's understanding, here's my heart
Taste Me.

You Are Beautiful

Your eyes are like auburn pools where light leaps and prances
Through their depths, forcing them to sparkle and glitter from this
 joyous ballet
Your smile is a warm comforter, soothing aches and pains
Its shine creates envy with the sun and stars
Paling them even in their most radiant state
Your voice is a loving symphony of nouns and verbs
Each word, sweeter than nature's honey, gently trickles off of your lips
 splashing into my thoughts.
Your skin, mother land for color, is chocolate in its flavoring.
The softness of satin is felt when we part ways and meet again with a
 kiss.
Your hair flows like a river of midnight
A dark waterfall raining from your crown
Blazing a path over your ears to pool at your shoulders
Your sweet essence, your warmth, your tenderness
Are all things that everyone, but most of all I love about you
So, take no regard to what anyone else may say, do or think
As seen through my loving eyes
You are beautiful

Love Addict

I find myself under bed sheets
Locked in a fetal position
Stomach rumbling
Hunger pains abundant
Suffering from that feminine malnutrition
Any thought other than of her
Runs random
Reminiscing of pulp fiction
She never belittles my body's stutter while inside of her
The squeeze of her lips helps control my diction
Craving for the next kiss
Direct contact
Hopefully more than just a little friction
I've come to realize she more than a habit
Greater than a drug addiction
I'm sprung for this woman
The awareness has gone well beyond simple intuition
I've dated the high school girls but she's definitely post grad
And here I am trying to scrape up the tuition
Hoping the hard work
Is more than enough to gain admission
Her style and grace has me feverish under the collar
I had to finally seek a physician
Who advised me that I've contracted a life changing disease
That he cannot seem to put into remission
No matter the treatment I have to accept I've fallen in love
The best kind of heart condition
Cupid finally hit me
Just when I thought he ran out of ammunition